⌜FRAMEABLES⌟

◆

21 prints
for a picture-perfect home

Animal Kingdom

Flammarion

The Animal Kingdom

The seventeenth and eighteenth centuries saw the foundation of institutions across Europe whose aim was to bolster development of the scientific disciplines from their roots in the universities, and to disseminate knowledge to the public. In 1663, the Royal Society of London for Improving Natural Knowledge (later Royal Society) was founded in London; in 1666, Colbert created the Royal Academy of Sciences in France, supporting the study of science and providing advice to the Crown.

In eighteenth-century Paris, Georges-Louis Leclerc, count of Buffon, was appointed head of the Jardin du Roi (King's Garden), developing it from a purely medicinal resource into a museum and research center that boasted botanical and zoological specimens from around the world. This was combined with the Cabinet d'Histoire Naturelle to become the Muséum National d'Histoire Naturelle in 1793. The extraordinary Collection des Vélins du Muséum National d'Histoire Naturelle (Vellum Collection of the Muséum National d'Histoire Naturelle) is illustrated with 6,500 watercolors of plants and animals, several of which are reproduced here.

At the time, history and genre painting were growing in popularity out of a concern for historical and natural truth. The worlds of science and art united, giving rise to the emergence of naturalist illustration. The structure of this new discipline coincided with an era of scientific expeditions, travel accounts, colonization, and the rise of maritime trade. Scientists and illustrators worked together to share the discoveries of the New World, using techniques such as drawing, painting, etching, lithography, and, in the modern period, photography; the aim was to capture the most minute details of their subjects—animal or plant—for scientific comparison.

By the early nineteenth century, the United States had also established its first natural science institution. The Academy of Natural Sciences of Philadelphia was founded in 1812; associate members included figures represented here, such as the zoologist and anatomist Georges Cuvier, naturalist Charles-Alexandre Lesueur, and the ornithologist, naturalist, and painter John James Audubon, famed for his exhaustive illustrations in The Birds of America. These scientific institutions, which were now springing up across the world, allowed for a global exchange of knowledge through written papers, correspondence, and lectures, as well as by means of detailed illustrative material—depicting a hitherto rarely seen animal kingdom that was exquisitely rich in color, form, and variety.

C. L.

PLATE CCCCXI

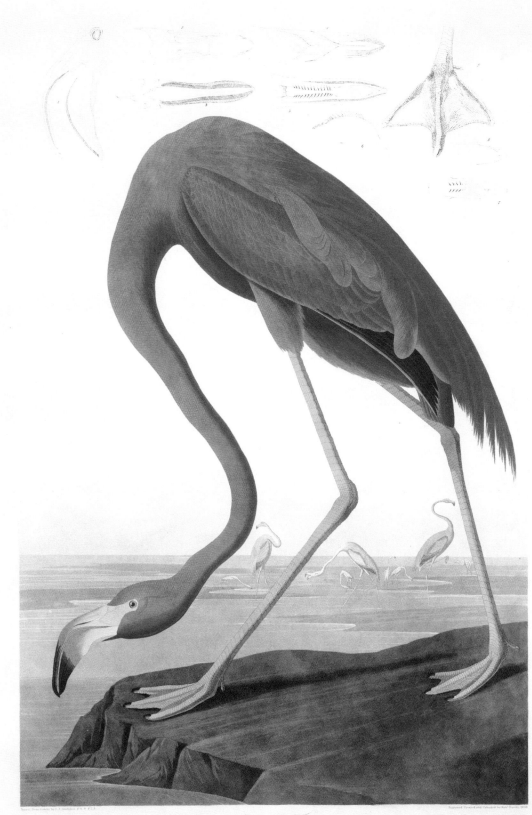

Phoenicopterus ruber

John James Audubon

American Flamingo
1827

Plate 431 in John James Audubon,
The Birds of America
Bibliothèque de l'Institut de France, Paris

John James Audubon, an American of French origin, was an ornithologist, naturalist, and painter. He was the first person to paint every species of bird found in North America, earning him the title of first ornithologist in the New World. The American flamingo—also called Caribbean flamingo—illustrated here is characterized by bright pink to red plumage that appears during the bird's development and reaches maximum intensity when it is between four and seven years old. The base of the bill is pale yellow, the middle pink or orange, and the tip black. The eyes are yellow, with a reddish internal orbital ring and a whitish external orbital ring. The remiges (long, rigid flight feathers) on the outside and underside of the wings are black. The feet are pink with red joints. The three anterior toes are webbed, enabling the American flamingo to stir up water and silt, into which it plunges its beak. Using its tongue and lamellae, it filters this mixture to retrieve small aquatic prey, including *Artemia salina* shrimp, which give flamingos their pink coloring, along with carotenoid-rich algae. The flamingo also feeds while swimming, shifting its body forward and paddling with its webbed toes, like ducks. It can dive to a depth of between 3 ft. 11 in. and 4 ft. 3 in. (1.20 to 1.30 m). The American flamingo spends the majority of its day feeding, preening its feathers, and resting, which it does standing on one foot with its head tucked under a wing. American flamingos fly fast, direct, and in groups.

Source: John James Audubon, *The Birds of America: From Drawings Made in the United States and Their Territories*, vol. 6, 1856

Description

- **Class:** Aves
- **Order:** Phoenicopteriformes
- **Family:** Phoenicopteridae
- **Genus:** *Phoenicopterus*
- **Habitat:** Caribbean islands, coastal Colombia and Venezuela, the Yucatan Peninsula, Florida, the Gulf of Mexico
- **Lifespan:** 30 years
- **Weight:** 4½ to 9 lb. (2.1 to 4.1 kg)
- **Height:** 3 ft. 11 in. to 4 ft. 9 in. (1.2 to 1.5 m)
- **Diet:** shrimp, mollusks, microscopic organisms, seeds, and algae
- **Characteristics:** very sociable and expressive

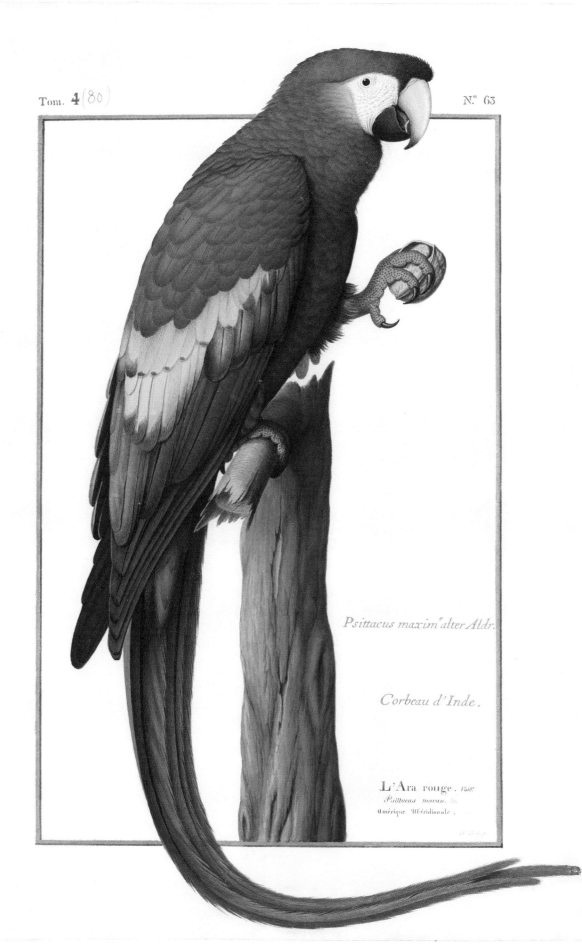

Psittacus maxim.ª alter Aldr.

Corbeau d'Inde.

L'Ara rouge. Taill.
Psittacus macao. L.
Amérique Méridionale.

Ara macao

Nicolas Robert

Scarlet Macaw

Seventeenth century

Plate in Nicolas Robert, *Collection des Vélins
du Muséum National d'Histoire Naturelle*,
case 80, Zoology, Birds, folio 63
Muséum National d'Histoire Naturelle,
Central Library, Paris

This specimen—the national bird of Honduras—is remarkable for its size, nearly half of which is tail. Its body is red; on its head, only the white skin around the eyes extends all the way to the bill. The wings feature a band each of red, yellow (sometimes accompanied by green), and dark blue. The flight feathers on the tail are dark red with gold metallic highlights, while the feathers on the croup and above the tail are light blue. Young birds have dark eyes, unlike adults, which have pale yellow eyes. The feet are charcoal black. Aras live in woods and humid areas, usually in pairs. They gather in the morning to screech brusque, strident calls. They also screech when they are frightened or surprised. Being very good flyers, they always perch on the tops of trees or on the highest branch. They fly early in the morning and return late in the evening to their resting and feeding area. The species is rare in Central America because of habitat modification brought on by deforestation and commercial interest in the bird. However, given the size of its territory, it is not considered to be in danger. Its beautiful feathers were used to make festival headdresses and other garments by indigenous American Indians.

Source: Georges-Louis Leclerc Buffon, *Oeuvres Complètes de Buffon* (The Complete Works of Buffon), new edition, 1884

Description

- **Class:** Aves
- **Order:** Psittaciformes
- **Family:** Psittacidae
- **Genus:** *Ara*
- **Habitat:** American tropical forests from eastern Mexico to the Peruvian and Brazilian Amazon
- **Lifespan:** 80 years
- **Weight:** 2 to 3¼ lb. (900 g to 1.5 kg)
- **Height:** 2 ft. 11 in. (89 cm)
- **Diet:** seeds, fruit, palm nuts
- **Characteristics:** very sociable, lives in groups

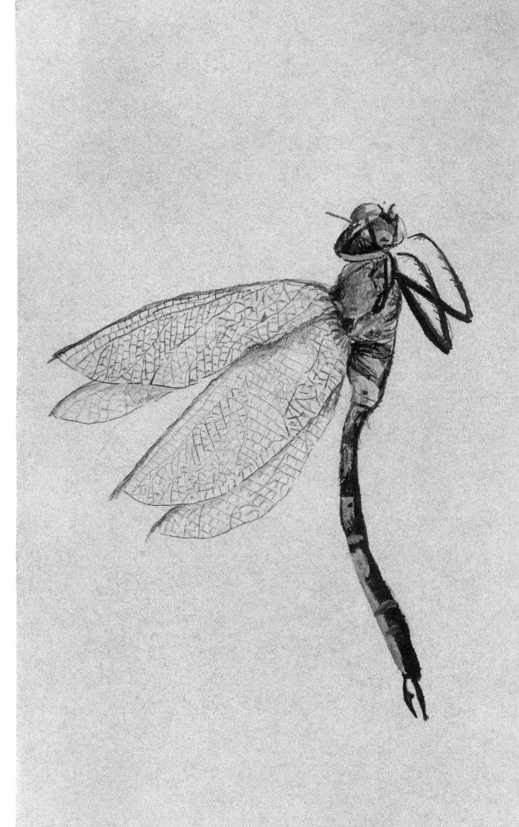

von O. Donnenberg

Coenagrion mercuriale

Marie-Françoise de Saint-Aubin

Southern Damselfly
(factitious collection)
Seventeenth century
Musée du Louvre, Paris

The male and female of this species are different. The male's body is blue and black, and the pattern on the second segment of the abdomen resembles a bull's head. Its *cercoides* (pincers) are longer than its *cerci* (stabilizing appendages). The female damselfly has a greenish back and black abdomen. Both fold their transparent wings when at rest. The hind and fore wings operate independently, which enables the damselfly to hover in place and fly backwards. They can reach a maximum speed of 22 mph (36 km/h). The *pterostigma* (a small area of increased thickness on the anterior margin of the wings) is diamond-shaped and black in the center. Their large, globular eyes are an advantage when hunting. The species shelters in small rivers, streams, rivulets, ditches, and fountains. Reproduction takes place in clear, well-oxygenated running water. Eggs are laid in aquatic plants, where the larvae develop over a period of twenty months; they are vulnerable to freezing temperatures and organic pollution. Damselflies begin flying in April in North Africa and southern Europe, and in May in northern Europe. They can be observed until August.

Source: Henri Miot, *Les Insectes Auxiliaires et les Insectes Utiles* (Helpful Insects and Useful Insects), 1870

Description

- **Class:** Insecta
- **Order:** Odonata
- **Family:** Coenagrionidae
- **Genus:** *Coenagrion*
- **Habitat:** Southern central and south-west Europe, northern Africa
- **Lifespan:** 5 years
- **Weight:** $\frac{2}{3}$ to $1\frac{1}{4}$ oz. (17 to 34 g)
- **Length:** $\frac{3}{4}$ to 1 in. (19 to 27 mm)
- **Diet:** flying insects
- **Near-threatened species**

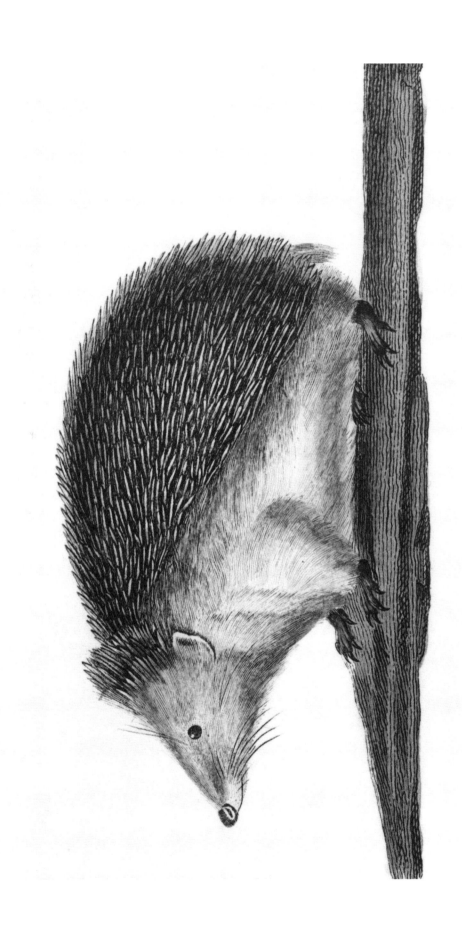

Erinaceus europaeus

Jean Gabriel Prêtre
West European Hedgehog
1816

Plate in Frédéric Cuvier, edited by Pierre
Jean François Turpin, *Le Dictionnaire
des Sciences Naturelles: Mammifères*
(The Dictionary of Natural
Sciences: Mammals)
Harvard University Herbarium,
Botany Libraries, Cambridge, MA

The European hedgehog has four limbs, a small tail, and thirty-six teeth. Its pointed muzzle and highly developed sense of smell enable it to detect food up to a depth of 1¼ in. (3 cm) underground. Its body is covered in hair at birth; the hairs on its back become hollow spines 1 to 1¼ in. (2 to 3 cm) long. Adults have 5,000 to 7,500 of these spines. The rest of the body is covered in long, stiff brown fur. The spines, which are replaced every eighteen months, provide defense against predators such as foxes, badgers, Eurasian eagle-owls, owls, wild boars, hawks, dogs, cats, and weasels. The European hedgehog defends itself by rolling face-down into a ball; it can stay like that for hours without tiring. If the predator continues its attack, the hedgehog also releases urine, which envelops its body in pungent humidity. The European hedgehog is very active, except during its hibernation period. Indeed, it may travel around 2½ miles (4 km) per day in search of food. A semi-nocturnal animal, it moves at speeds of up to 10 ft. (3 m) per minute at night and rests during the day. Before hibernating, the hedgehog builds itself a protective nest. During the hibernation period, it burns around ⅒ oz. (2 g) of fat per day and its body temperature may drop to around 36°F–41°F (2°C–5°C). It is therefore imperative for the hedgehog to awaken at least once a week to eliminate excess acidity from its blood. When its fat reserves fall too low, the hedgehog must go hunting again, whether or not spring has arrived.

Source: Georges-Louis Leclerc Buffon, *Oeuvres Complètes de Buffon*
(The Complete Works of Buffon), volume 9, new edition, 1884–86

Description

◆ **Class:** Mammalia
◆ **Order:** Eulipotyphla
◆ **Family:** Erinaceidae
◆ **Genus:** *Erinaceus*
◆ **Habitat:** Europe (except for the far north, Turkey, and Caucasia)
◆ **Lifespan:** 2 to 3 years
◆ **Weight:** 10½ oz. to 4½ lb. (300 g to 2 kg)
◆ **Length:** 8 to 12 in. (20 to 30 cm)
◆ **Diet:** insects, worms, snails, slugs, eggs, fruit, berries, snakes, lizards, rodents, batrachians (amphibians), birds
◆ **Characteristics:** very active, with a highly developed sense of smell and sense of direction
Near-threatened species

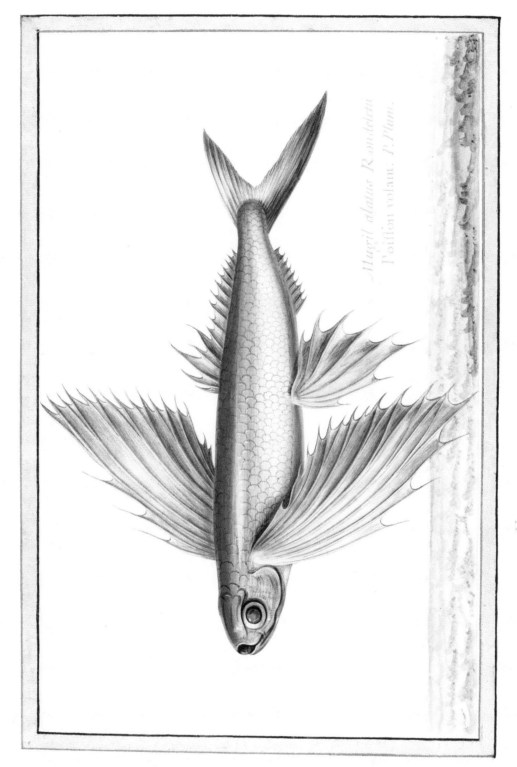

Exocoetus volitans

Anonymous
Flying Fish
Undated

Plate in *Collection des Vélins du Muséum
National d'Histoire Naturelle*, case 93, folio 55
Muséum National d'Histoire Naturelle,
Central Library, Paris

Exocoetus volitans is the common flying fish. By extending its pectoral fins, it is able to glide above the surface of the water in order to escape predators. To prepare for flight, the fish swims near the surface, its fins held close to its body. Once airborne, it opens its fins, including its very spiky caudal fin. It doesn't flap its wings during flight because it is actually gliding. It can reach speeds exceeding 37 mph (60 km/h) over a distance of 98 to 164 ft. (30 to 50 m). It lands at 20 mph (32 km/h) and is capable of jumping several times in a row. It has a large head and a blue, yellow, and red body made up of hard scales arranged in parallel lines. The underside is flat and white with red highlights. The fish has large eyes with red-tinted yellow irises. The first dorsal fin has five spokes, of which the first is the longest, and the others are of decreasing length; the chest fins are the fish's wings and are very developed. Its main predators are the swordfish, tuna, and dolphin. The flying fish is a staple food of the Da'o people, who inhabit Orchid Island (Taiwan), and its eggs are used in Japanese cuisine. Its flesh is hard, coarse, and very nourishing, but difficult to digest. The name of this fish was given to the guided missile Exocet and three US Navy ships called the USS *Flying Fish*.

Source: Georges Cuvier, *Histoire Naturelle des Poissons* (A Natural History of Fish), volume 19, 1828–49
Encyclopédie Méthodique. Histoire Naturelle. Histoire Naturelle des Animaux (Methodical Encyclopedia. Natural History. Natural History of Animals), volume 3, fish, 1782–84

Description

- **Class:** Actinopterygii
- **Order:** Beloniformes
- **Family:** Exocoetidae
- **Genus:** *Exocoetus*
- **Habitat:** tropical and subtropical waters with temperatures between 68°F and 84°F (20°C and 29°C)
- **Lifespan:** 12 years
- **Weight:** ½ oz. to 2 lb. 4 oz. (100 g to 1 kg)
- **Length:** 8 to 12 in. (20 to 30 cm)
- **Diet:** crustaceans and plankton
- **Characteristics:** lives in schools

VOYAGE AU PÔLE SUD ET DANS L'OCÉANIE.

Peint par Werner.

Gravé par Mme Eugene.

Dirigé par Borromée.

Imp.re de Bougeard.

Chle. Editeur.

1. RORQUAL VOUEUX (Nos 2.3.4.5.6.) – Fœtus de Dauphin et son anatomie.

Megaptera novaeangliae

Égasse & Jean-Charles Werner

Humpback Whale, Dolphin Fetus, and Its Anatomy
1842–53

Plate in J. Dumont D'Urville, *Voyage au Pôle Sud et dans l'Océanie sur les Corvettes l'Astrolabe et la Zelle* (Voyage to the South Pole and Oceania on the Corvettes *Astrolab* and *Zelle*), 2, Zoology, volume 3 Muséum National d'Histoire Naturelle, Central Library, Paris

The humpback whale's massive body is black on the upper side and white on the underside. Females are larger than males and are differentiated by a hemispherical lobe in the genital area. Small hair-like follicles cover the head and lower jaw. The dorsal fin is located two-thirds of the way along the back. The extremely long pectoral fins grow to a third of the animal's total length. The caudal fin, or the tail, is large and powerful, and features patterns unique to each animal. The whale's jaw is fitted with anywhere from 270 to 400 baleen plates, which filter water to extract food. The humpback whale uses two techniques to catch its prey. The first involves circling prey to create a bubble net, then charging them, mouth agape. The second method involves stunning prey by slapping the water with its flippers. The humpback whale is a migratory animal and travels around 15,500 miles (25,000 km) each year. It alternates between cold waters in the summer, where it searches for food, and tropical waters for reproduction and birth. During this period, males may breach to a height of 16 ft. (5 m) in their efforts to charm females. These leaps are accompanied by songs composed of low tones that vary in amplitude and frequency and can last for several days. This undersea creature dives for 8 to 15 minutes, and sometimes up to 30 minutes. When it surfaces, the spray from its blowhole can travel 10 ft. (3 m) high as it expels air from its lungs. Although hunting wiped out 90 percent of the population in the twentieth century, a moratorium currently protects humpback whales from all forms of hunting, allowing the species to gradually recover.

Source: Frédéric Cuvier, *De l'Histoire Naturelle des Cétacés* (A Natural History of Cetaceans), or *Recueil et Examen des Faits Dont Se Compose l'Histoire Naturelle des Animaux* (Collection and Examination of the Facts That Make Up the Natural History of Animals), 1836

Description

- **Class:** Mammalia
- **Order:** Cetacea
- **Family:** Balaenopteridae
- **Genus:** *Megaptera*
- **Habitat:** oceans and seas between the 60th parallel south and the 65th parallel north
- **Lifespan:** 40 to 100 years
- **Weight:** 27½ tons (25 metric tons)
- **Length:** 42½ to 46 ft. (13 to 14 m)
- **Diet:** krill, schools of small fish like herring, capelin, and sand eel
- **Characteristics:** curiosity, elaborate songs

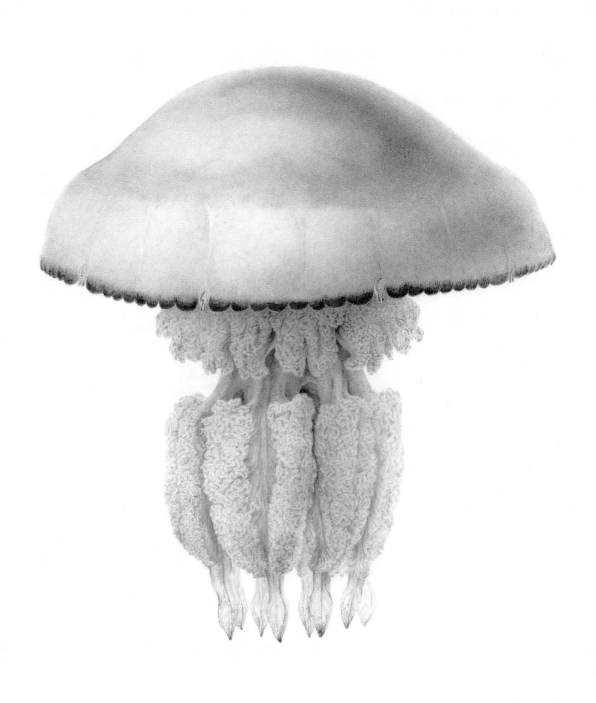

Rhizostoma cuvieri

Charles-Alexandre Lesueur

Rhizostoma cuvieri (jellyfish)
1800–1804

Plate in Charles-Alexandre Lesueur,
Vélin (Vellum)
Muséum d'Histoire Naturelle, Le Havre

In 1801, the French naturalist and artist Charles-Alexandre Lesueur joined the Baudin expedition, which was mapping the coast of Australia. Teaming up with the naturalist François Péron, Lesueur collected thousands of specimens, and he illustrated major treatises on zoology with his drawings of jellyfish. *Rhizostoma*, depicted here, moves slowly through shallow water and is easily observed in coastal areas, lagoons, and estuaries. *Rhizostoma* is a large, imposing jellyfish that appears in a wide variety of colors, including white, yellow, orange-brown, green, blue, and light purple. The bell-shaped umbrella is fringed with eighty to one hundred lobes. Its finely serrated edges are trimmed in blue or light purple. Under the umbrella, the manubrium is formed by the intersection of four oral arms, each separated into two sections, forming a total of eight lobes. Each of these eight lobes is tipped with two small transparent tongues. This fusion turns the mouth into a sucking and filtrating structure with many small perforations called ostioles, which enable the jellyfish to aspirate small zooplankton prey. Some fish species, like *Boops*, *Seriolas*, and *Trachurus*, and symbiotic algae, find refuge under the umbrella or in the arms of the jellyfish. It is easy to tell male and female *Rhizostoma* apart: male gonads (reproductive organs) are blue while female gonads are orange-brown. Although this jellyfish has no tentacles and is harmless, some people experience skin irritation or redness upon contact. The right conditions can give rise to blooms of dozens or even hundreds of jellyfish. *Rhizostoma* was the model for a chandelier created for the oceanographic museum in Monaco.

Source: Société Zoologique de France, *Bulletin de la Société Zoologique de France* (Bulletin of the Zoological Society of France), 1931
Société des Sciences Naturelles (Charente-Maritime), *Annales de la Société des Sciences Naturelle de la Charente-Maritime* (Annals of the Natural Sciences Society of Charente-Maritime), 1984

Description

- **Phylum:** Cnidaria
- **Order:** Rhizostomae
- **Family:** Rhizostomatidae
- **Genus:** *Rhizostoma*
- **Habitat:** Atlantic Ocean and Mediterranean Sea
- **Lifespan:** 2 months to 1 year
- **Weight:** 98 percent water
- **Size:** 12 to 24 in. (30 to 60 cm) in diameter
- **Diet:** small zooplankton and fish
- **Characteristics:** does not sting

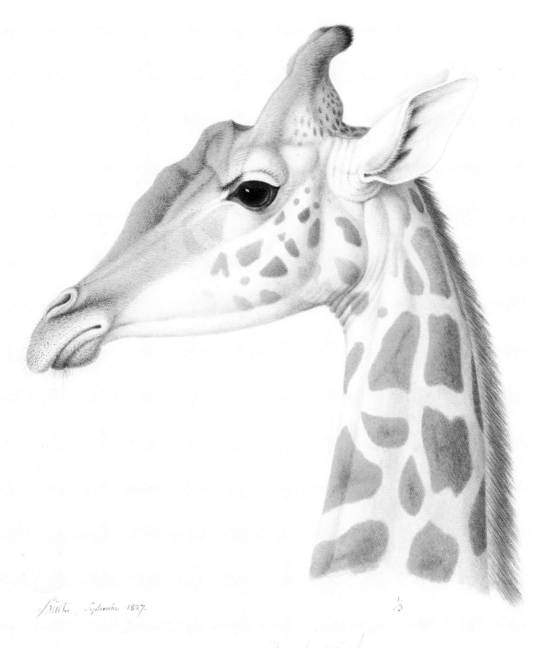

Giraffa reticulata

Nicolas Huet
Head of a Reticulated Giraffe
1827

Plate in Nicolas Huet, *Collection des Vélins du Muséum National d'Histoire Naturelle,* case 73, Zoology, Mammals, folio 38a, Muséum National d'Histoire Naturelle, Central Library, Paris

The reticulated giraffe has a unique hide that is prized by poachers. Its coat features large polygonal markings structured by a network of bright white lines. These markings are dark brown and cover the animal's entire body. The tallest land mammal, the giraffe has a disproportionate and rather complex morphology: its forelegs are longer than its hind legs. Its head and torso are smaller in size, and its long neck has just seven vertebrae. Studies of the giraffe's circulatory system contributed to the development of an anti-g suit for pilots and astronauts: the giraffe has an inbuilt system for regulating the blood flow so that pressure is reduced before it enters the brain and controlled as it leaves. In this way, the head does not swell when it bends its neck down and the blood does not drain away too rapidly when it lifts its head up again. The giraffe's heart weighs 24¼ lb. (11 kg); it pumps 16 gallons (60 liters) of blood per minute, and the heart rate can reach 170 beats per minute when running. Although it does not travel far, it is capable of walking 3 to 4½ mph (6 to 7 km) and can run at speeds of up to 35 mph (56 km/h). Too vulnerable lying down, the giraffe must sleep and give birth standing up; giraffe calves therefore start life with a fall of 6 ft. 6 in. (2 m). The giraffe sleeps no more than three or four minutes per hour for a total of two hours a day. A desert animal, it maintains a body temperature of between 95°F and 102°F (35°C and 39°C) throughout the day and night. Like the dromedary, it can go without water for several days. Giraffes hydrate themselves by eating acacia leaves—grasped with the help of a long, rough, very narrow black tongue they wrap around food—and by retaining a large portion of the humidity contained in their breath.

Source: Étienne Geoffroy Saint-Hilaire, *Sur la girafe* (On the Giraffe), 1827

Description

* Class: Mammalia
* Order: Artiodactyla
* Family: Giraffidae
* Genus: *Giraffa*
* Habitat: Somalia, southern Ethiopia, northern Kenya
* Lifespan: 30 years
* Weight: 1,500 lb. to 2 tons (700 to 1,900 kg)
* Height: 14 to 17 ft. (4.3 to 5.3 m)
* Diet: leaves, young trees and shrubs, climbing plants, certain low-lying plants, flowers, pods, and seasonal fruit
* Characteristics: excellent vision, very good sense of hearing and smell, sociable, calm, herd instinct

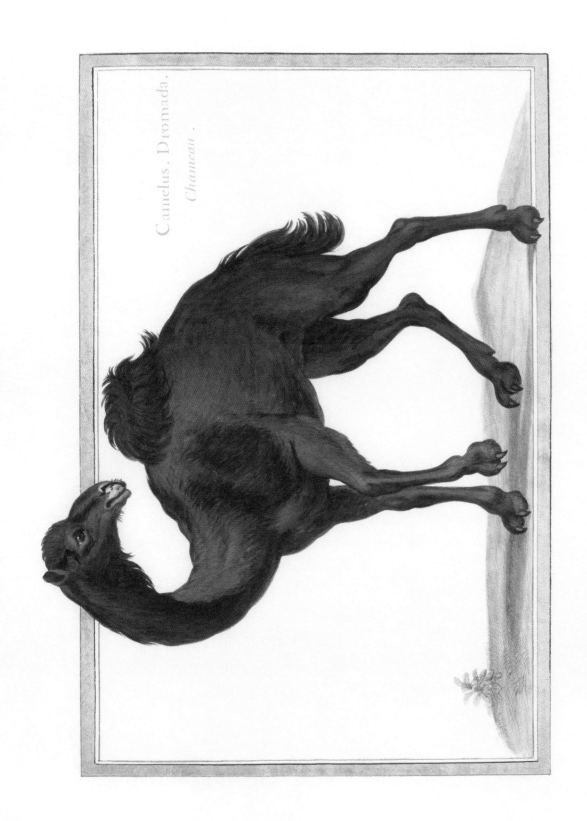

Camelus. Dromada.
Chameau .

Camelus dromedarius

Anonymous
Dromedary
1822

Plate in Nicolas Huet, *Collection des Vélins du Muséum National d'Histoire Naturelle*, case 73, Zoology, Mammals, folio 3
Muséum National d'Histoire Naturelle, Central Library, Paris

Unlike the camel, the dromedary has only one hump, a mass of whitish fat weighing in excess of 220 lb. (100 kg). To survive in a desert climate, the dromedary can forgo drinking for two to three weeks in the hot season and four to five weeks in the cool season. When it finally quenches its thirst, the animal can drink up to 4 gallons (15 liters) per minute. Additionally, its muzzle recovers a large portion of the water vapor exhaled through its nasal passageways. The dromedary also has the capacity to vary its body temperature from 93°F to 106°F (34°C to 41°C), which enables it to reduce the amount of water lost through perspiration and to survive in a desert environment. The animal's fur is soft and wooly, and used to make cloth and felt. This fur is unevenly distributed; it is longer around the neck, under the throat, and on the chest and hump. There are some large hairless calluses on the fore-knees and the kneecaps, and on the hind legs; these protect the dromedaries from the burning sands when they lie down. Fur color changes with age, shifting from pale white in juveniles to reddish gray in adults. Dromedaries can be divided into two groups, broadly speaking: the racing dromedary (which can run at 31 mph and up to 44 mph [50 to 70 km/h]) and the working dromedary, which can move at speeds of 2½ to 4½ mph (4 to 7 km/h) and walk 25 to 31 miles (40 to 50 km) per day when carrying a full load, which is where it gets the sobriquet "ship of the desert."

Source: Alexandre Vallon, *Mémoire sur l'Histoire Naturelle du Dromadaire* (Essay on the Natural History of the Dromedary), 1856

Description

- ◆ **Class:** Mammalia
- ◆ **Order:** Artiodactyla
- ◆ **Family:** Camelidae
- ◆ **Genus:** *Camelus*
- ◆ **Habitat:** arid regions of Africa (more specifically the Sahara Desert), India, and the Near and Middle East
- ◆ **Lifespan:** 25 years
- ◆ **Weight:** racing dromedary: 880 to 1,322 lb. (400 to 600 kg); working dromedary: 1,763 to 1¼ tons (800 to 1,100 kg)
- ◆ **Height:** 7 ft. 3 in. to 8 ft. 3 in. (2.2 to 2.5 m) at the withers
- ◆ **Diet:** thorny plants, dry grass, leaves, seeds
- ◆ **Characteristics:** adapted to extreme dryness and heat
Wild dromedaries are extinct

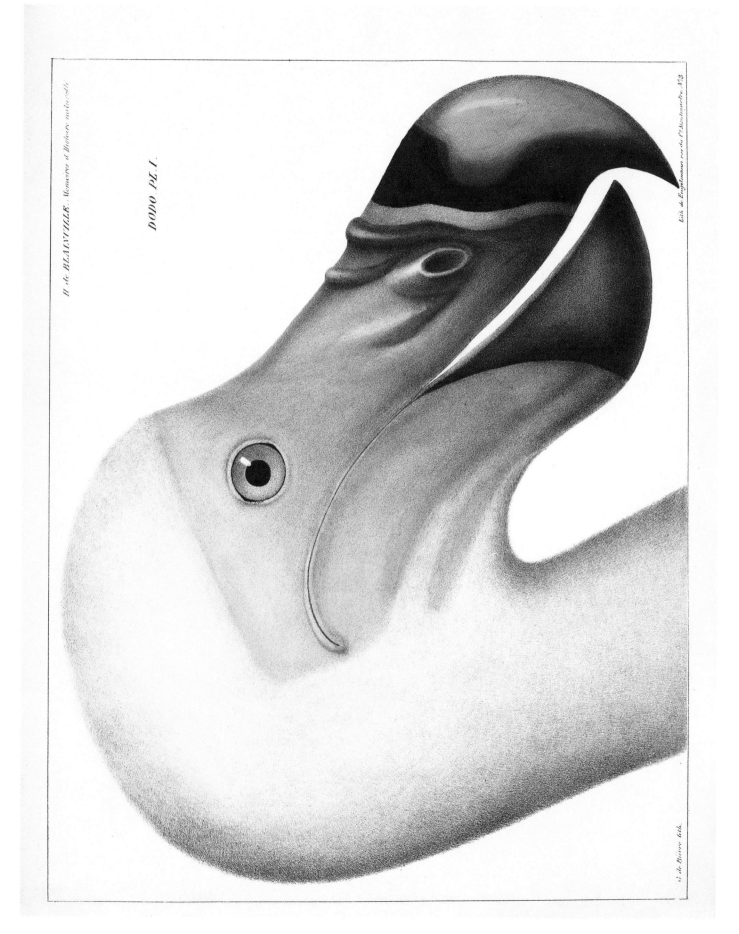

DODO. Pl. I.

G. de Bevre lith.

Litt. de Engelmann rue du Vdbatomartre N.3

Raphus cucullatus

Godefroy Engelmann & Jean-Gabriel Prêtre

Dodo's Head

1835

Plate in H. D. de Blainville,
Nouvelles Annales du Muséum National d'Histoire Naturelle or *Recueil de Mémoires*
(New Annals of the Muséum National d'Histoire Naturelle *or* Collected Essays), volume 4
Muséum National d'Histoire Naturelle, Central Library, Paris

The dodo—now extinct—was symbolic of the island of Mauritius. Its head was covered in a sort of membrane; its bill was thick and oblong, yellowish near the head, blue halfway along the inferior mandible, and black at the tip. The upper mandible was hook-shaped. The body was covered in short, sparse, usually white or gray feathers. Four or five black feathers indicated the presence of atrophied wings. The hindquarters were very thick and fatty. Instead of a tail, the dodo had several short, frizzy, furled, ash-colored feathers. Small black feathers covered its upper legs, and yellow feathers its feet, which featured four toes with black nails. The bird's extirpation can be explained by several causes. With no natural predators, the dodo lost its ability to fly as it evolved. It built its nest in palm leaves on the ground, leaving its vulnerable eggs at the mercy of predators. Never having developed a fear of humans, the dodo made for easy prey and it was hunted without mercy—its white feathers were particularly sought after. The introduction of pigs, rats, dogs, and other animals to the island also contributed to its extinction. The species was introduced to other areas, but this was only done with isolated individuals, which prevented reproduction from taking place. The last dodo died in 1681.

Source: H.D. de Blainville, *Nouvelles Annales du Muséum National d'Histoire Naturelle or Recueil de Mémoires*, volume 4, 1832–35

Description

◆ **Class:** Aves
◆ **Order:** Columbiformes
◆ **Family:** Raphidae
◆ **Genus:** *Raphus*
◆ **Habitat:** island of Mauritius
◆ **Lifespan:** 30 years
◆ **Weight:** 22½ lb. (10.2 kg)
◆ **Height:** 3 ft. 4 in. (1 m)
◆ **Diet:** seeds of the tambalacoque tree, fruit, small insects
◆ **Characteristics:** agile, sometimes aggressive
Extinct species

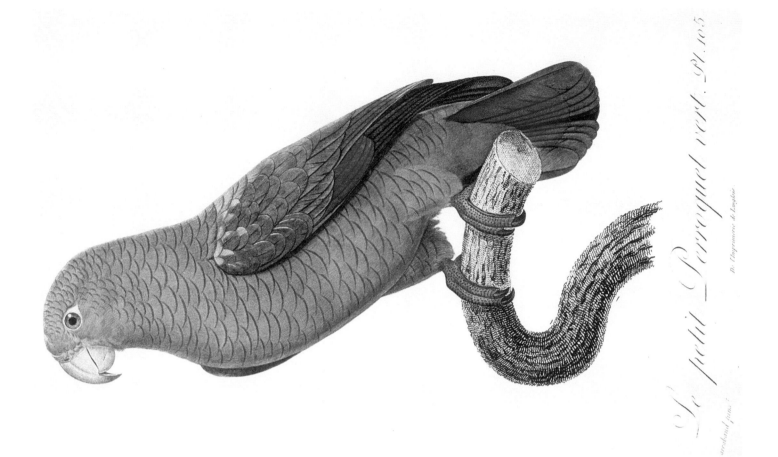

*arrobaud pinx.*t

D. l'Imprimerie de Langlois

Le petit Perroquet vert. Pl. 105.

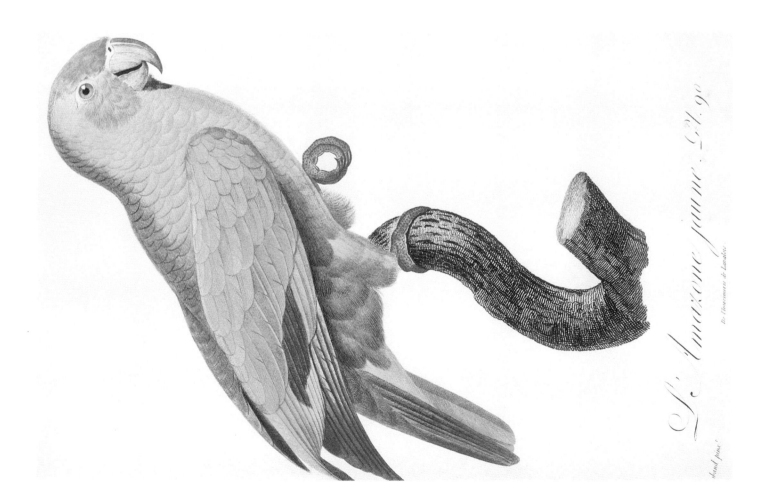

*band pinx.*t

De l'Imprimerie de Langlois

Le Amazone jaune. Pl. 90.

Amazona agilis

Jacques Barraband
Little Green Parrot
1801–5

Plate in François Levaillant,
Histoire Naturelle des Perroquets
(A Natural History of Parrots), volume 2, folio 105
Muséum National d'Histoire Naturelle,
Central Library, Paris

Description

- **Class:** Aves
- **Order:** Psittaciformes
- **Family:** Psittacidae
- **Genus:** *Amazona*
- **Habitat:** John Crow Mountains, Jamaica
- **Lifespan:** 40 years
- **Weight:** 6¼ oz. (178 g)
- **Height:** 10 in. (25 cm)
- **Diet:** seeds, nuts, fruit
- **Characteristics:** calm

Endangered species, vulnerable

Amazona oratrix

Jacques Barraband
Yellow Amazon
1801–5

Plate in François Levaillant,
Histoire Naturelle des Perroquets
(A Natural History of Parrots), volume 2, folio 90
Muséum National d'Histoire Naturelle,
Central Library, Paris

Description

- **Class:** Aves
- **Order:** Psittaciformes
- **Family:** Psittacidae
- **Genus:** *Amazona*
- **Habitat:** Atlantic and Pacific coasts of Mexico, Belize, and Honduras
- **Lifespan:** 40 to 50 years
- **Weight:** 10½ oz. to 1 lb. (350 to 500 g)
- **Height:** 14¼ in. (36 cm)
- **Diet:** fruit, nuts, berries, seeds gleaned from farmland
- **Characteristics:** very cheerful personality, stubborn, hearty eater, agreeable, playful, curious and affectionate, capable of talking

Endangered species

For a 15 × 20 cm frame
For a 6 × 8 in. frame

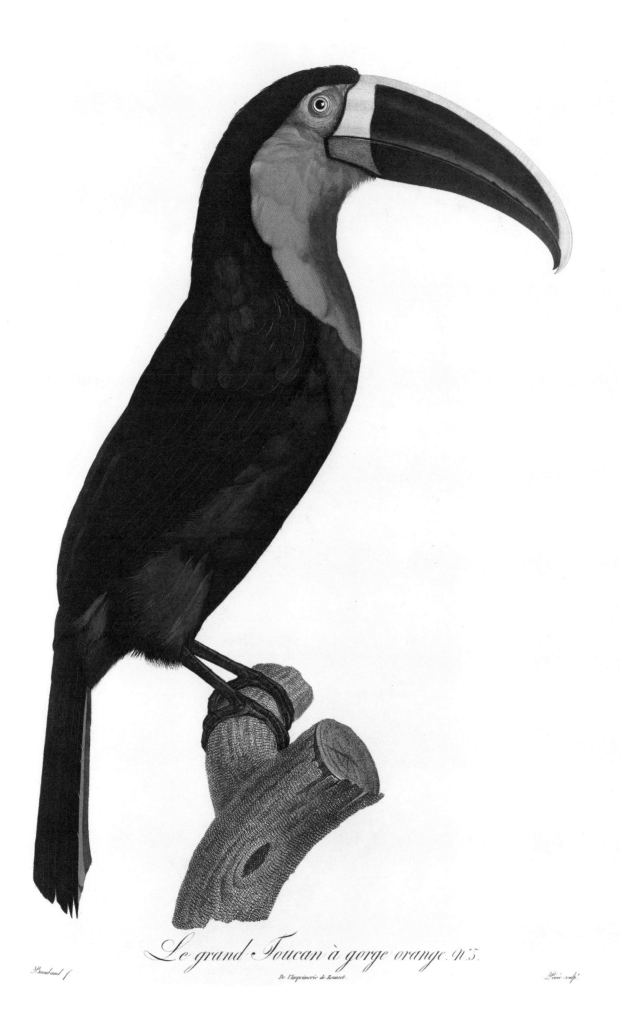

Le grand Toucan à gorge orange. n°5.

Bareband f. De l'Imprimerie de Rousset. Pérée sculp.

Ramphastos vitellinus ariel

Jacques Barraband & Amédée Pérée

Ariel Toucan
1806–7

Plate in François Levaillant, *Histoire Naturelle des Oiseaux de Paradis et des Rolliers, Suivie de Celle des Toucans et des Barbus* (A Natural History of Birds of Paradise and Rollers, Followed by That of Toucans and Barbets), folio 5
Muséum National d'Histoire Naturelle, Central Library, Paris

The Ariel toucan—a subspecies of the Channel-billed toucan (*Ramphastos vitellinus*)—is characterized by an enormous, entirely black, slightly hooked bill with a yellow band at its base. A large vertical yellow strip is visible on the upper mandible. Unlike other birds of this species, the throat, the sides, and the front of the neck extending to the breast are entirely yellow-orange, without a hint of white. The yellow-orange neck gives way to a vermilion, breastplate-shaped collar (gorget) on the breast. The rest of the bird's plumage is identical to that of the nominate race (*R. v. vitellinus*), which has a black upper body, wings, and tail. The forehead, crown, back of the neck, and coat are also black. The coverts located above the tail are bright red. The claws and feet are gray-blue. This hardy toucan lives in the humid Amazon forest, where it nests in the middle story, using its beak to hollow out hardwoods to build its nest. It feeds on fruit, which it snips off using the tip of its bill, tosses into the air, and swallows whole, along with birds and small vertebrates. Its song is a series of droning, croaking notes composed of two syllables: the first is a clear "eeee," followed by an "okkk," "aargh," or louder "eerk."

Source: François Levaillant, *Histoire Naturelle des Oiseaux de Paradis et des Rolliers, Suivie de Celle des Toucans et des Barbus* (A Natural History of Birds of Paradise and Rollers, Followed by That of Toucans and Barbets), folio 5, 1806

Description

- Class: Aves
- Order: Piciformes
- Family: Ramphastidae
- Genus: *Ramphastos*
- Habitat: Brazil
- Lifespan: 25 years
- Weight: 13¼ oz. (375 g)
- Height: 1 ft. 5 in. (45 cm)
- Diet: soft, juicy fruit; spiders; ants; small vertebrates; eggs pillaged from the nests of other birds
- Characteristics: unsociable, solitary, never leaves the forest cover

Endangered, vulnerable species

Tersine verte. *Vieill.*

Tersina viridis.

Du Brésil.

1. mâle. 2. femelle.

Tersina ❖ *viridis*

Nicolas Huet
Swallow Tanager
1815

Plate in Nicolas Huet, *Collection des Vélins du Muséum National d'Histoire Naturelle*, case 78, Zoology, Birds, folio 33
Muséum National d'Histoire Naturelle, Central Library, Paris

Sexual dichromatism is present in swallow tanagers. The male has turquoise plumage; the forehead, eye area, and throat are black, while the abdomen and undertail coverts are white, and the flanks striped black. The coverts under the wings are blue; the flight feathers and tail feathers are black with turquoise edges. The female has a bright green chest. The eye area and throat are striped with gray and white. The abdomen and undertail coverts are pale yellow. The flanks are yellow with green stripes. The remiges (large, stiff wing feathers) are black with green edges. The swallow tanager lives in forests and humid plains, in treetops and along the forest canopy. It always holds itself very straight when perched, unlike other birds of the same species. Resistant to disturbances, it is not uncommon to find these birds in forests recently affected by fire. The bird's song is composed of a simple note: "tsee." During the reproduction period, the note is repeated with monotonic regularity. The species builds its nest in hollowed-out trees, sandbars, and cracks in walls. An insectivore, the swallow tanager rises 10 to 33 ft. (3 to 10 m) above the trees to catch insects. It is capable of eating while opening its beak to trap new prey, which it stores in its throat sac.

Source: Zéphirin Gerbe, Georges Cuvier, *Les Oiseaux Décrits et Figurés d'Après la Classification de Georges Cuvier, Mise au Courant des Progrès de la Science* (Birds Described and Illustrated According to George Cuvier's Classification, Updated to Reflect Scientific Progress), 1869

Description

- **Class:** Aves
- **Order:** Passeriformes
- **Family:** Thraupidae
- **Genus:** *Tersina*
- **Habitat:** South America, from Panama to northern Argentina
- **Lifespan:** unknown
- **Weight:** ¾ to 1 oz. (25 to 30 g)
- **Height:** 5½ in. (14 cm)
- **Diet:** fruit rich in fat and protein, Magnoliaceae and Araliaceae seeds, moths, flies, ants, termites, grasshoppers, beetles
- **Characteristics:** the only species in the genus *Tersina*

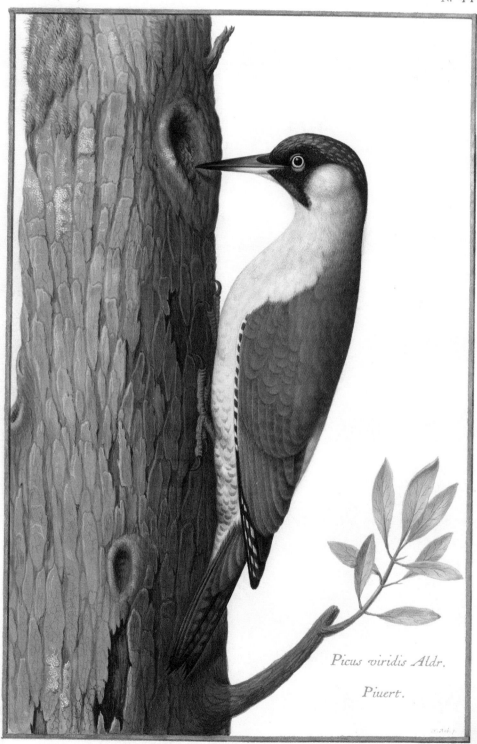

Picus viridis Aldr.

Piuert.

Le Pic vert, *mâle. Buff.*
Picus viridis. Lin.
d'Europe.

Picus viridis

Nicolas Robert
Eurasian Green Woodpecker
Seventeenth century

Plate in Nicolas Robert, *Collection des Vélins du Muséum National d'Histoire Naturelle,* case 80, Zoology, Birds, folio 44
Muséum National d'Histoire Naturelle, Central Library, Paris

Characterized by its predominately green plumage, for which it is named, the green woodpecker is also remarkable for its red, black, and white head. The body, from the neck to the tail, including the wing feathers, is green with yellow highlights. The croup and the feathers above the tail are closer to yellow. The remiges (large wing feathers) and rectrices (the largest of the stiff tail feathers) are grayish brown with black stripes. The throat and cheeks are white and the lower belly is yellow. The feathers behind the flanks and the undertail coverts (feathers under the tail) are yellow with black edges. The beak is yellow with a dark tip. The heavily clawed feet are brownish or grayish. Males and females are distinguished by the color of their mustache, which is black in females and red ringed with black in males. The woodpecker punctuates its flight with loud single or repeated "kiak" sounds. The song is composed of the same note repeated an average of ten times to form a phrase. When the bird is on the ground searching for food, it keeps quiet to protect itself from predators as it bounces along in search of the anthills that provide most of its diet. It extracts its food using its long sticky tongue lined with tiny barbs. Unlike the great spotted woodpecker and others, the green woodpecker only pecks wood to build its nest, which is usually located 6½ to 33 ft. (2 to 10 m) high. It takes the bird several weeks to make a hole of between 2¼ and 2¾ in. (6 to 7 cm) in diameter, where it lays five to eight eggs in a single annual clutch.

Source: Dr. J-C. Chenu (gen. ed.), *Les Trois Règnes de la Nature: Lectures d'Histoire Naturelle* (The Three Kingdoms of Nature: Readings in Natural History), 1863

Description

- Class: Aves
- Order: Piciformes
- Family: Picidae
- Genus: *Picus*
- Habitat: Europe, Asia, northern Africa
- Lifespan: 7 to 8 years
- Weight: 7 oz. (200 g)
- Height: 12 to 17¾ in. (30 to 45 cm)
- Diet: insects (including ants), larvae, fruit
- Characteristics: singer, unafraid, discreet on the ground, solitary

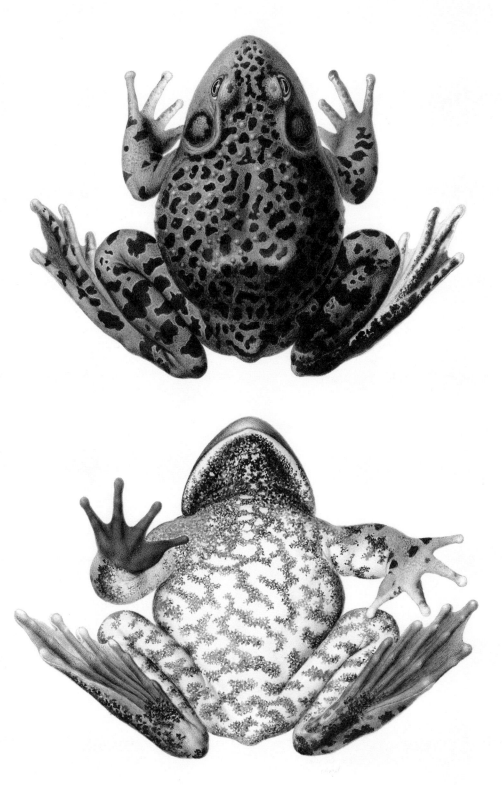

Rana mugiens

Antoine Chazal
Frog from a Live Specimen
1834

Plate in *Collection des Vélins du Muséum National d'Histoire Naturelle*, volume 88, Zoology, Reptiles and Batrachians, folio 54
Muséum National d'Histoire Naturelle, Central Library, Paris

Rana mugiens, the largest frog found in North America, also goes by the names of ouaouaron or bullfrog. Olive green to dark brown in color, with darker spots on its back, it has a cream-colored abdomen flecked with gray. The female has a cream-colored throat, unlike the male, which has a yellow throat. To mark its territory, the bullfrog emits a series of five or six deep croaks. The low, slow sounds resemble the lowing of a bull. The frog inhabits a space estimated to be between 10 and 115 ft. (3 and 35 m) of riverbank, which varies from one individual to the next. It moves by jumping, walking, or swimming, assisted by its strong feet. During the hibernation period, the frog shelters in the mud in a small cave to protect itself from outside attacks. It emerges from its shelter when the water temperature exceeds 55°F (13°C) and the air temperature reaches between 68°F and 75°F (20°C and 24°C). The bullfrog is now present around the world, following intentional introduction by humans and due to its own capacity to reproduce. This proliferation allows a response to several needs: Breeding—for the creation of bags and shoes—and meat, but also as pets or for games (frog jumping contests), or to contain destructive insects and other pests. Today, the species is considered invasive and provokes biological imbalances that disrupt natural ecosystems.

Source: Edmond Perrier, *Traité de Zoologie: Batraciens* (Treatise on Zoology: Batrachians), 1893–1932

Description

- ◆ **Class:** Amphibia
- ◆ **Order:** Anura
- ◆ **Family:** Ranidae
- ◆ **Genus:** *Lithobates*
- ◆ **Habitat:** Originally North America, today worldwide
- ◆ **Lifespan:** 8 to 9 years
- ◆ **Weight:** 1¼ to 2¼ lb. (600 g to 1 kg)
- ◆ **Height:** 4¼ to 7¼ in. (11.1 to 18.3 cm)
- ◆ **Diet:** frogs, toads, small fish, crawfish, small reptiles
- ◆ **Characteristics:** aggressive, territorial
- **Invasive species**

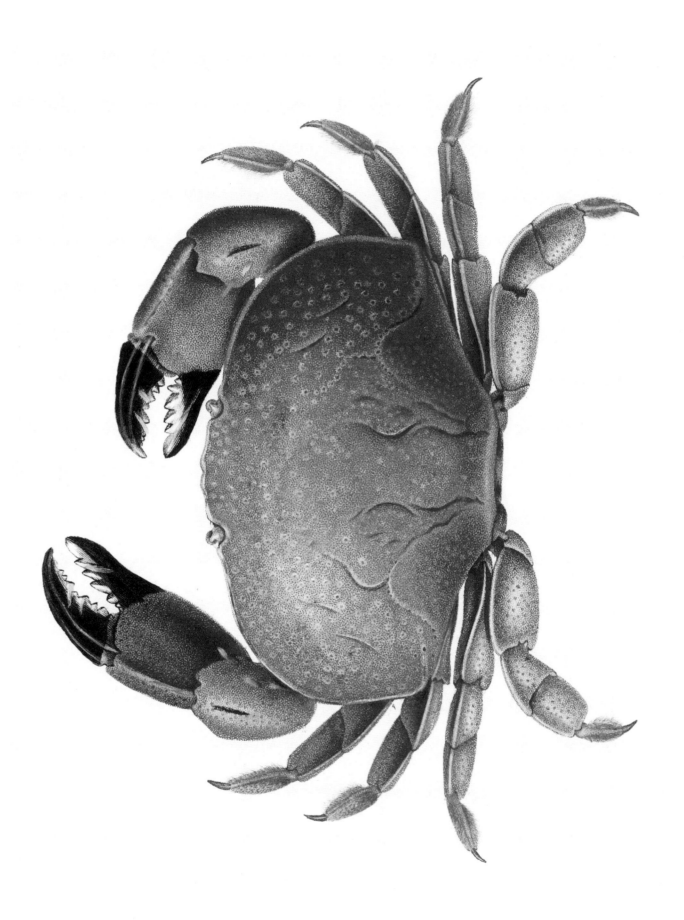

Cancer pagurus

Georges Cuvier
Very Complete Crab
1836–49

Plate in Georges Cuvier, *Le Règne Animal Distribué d'Après Son Organisation* (The Animal Kingdom Organized According to Its Structure), volume 17 Muséum National d'Histoire Naturelle, Central Library, Paris

Georges Cuvier, the founding father of paleontology, used comparative anatomy and the laws of correlation to create the natural classification system used in zoology. He studied crustaceans in particular, with the brown, or edible, crab depicted here. This crab is elliptical in form and beige-brown in color, with orange and whitish-yellow highlights on the underside. Its shell is twice as wide as it is long. It is the largest crab found on European coasts. A dozen rounded lobes are present on the lateral edges of the smooth shell. The crab has five pairs of legs, all of which contribute to locomotion. The first pair are made up of two large pincers with black fingers. These hardy pincers are capable of slicing through a human finger. The other pairs are smaller and covered in fine hairs. The eyes are often sea green; they are surrounded by the rostrum (an elongated projection near the front of the body), composed of five short spikes and very short antennas. Like all crustaceans, the brown crab molts. This always takes place underwater and at night. In fact, the brown crab is active at night and hides during the day. Water temperature and photoperiod (the ratio of day to night) triggers the hormonal system and enables molting to begin, a process that takes thirty minutes to six hours. To exit its exoskeleton, the brown crab expands its body by absorbing water, which is then replaced by organs and flesh. It is principally for this flesh that the brown crab is prized.

Source: Georges Cuvier, *Le Règne Animal Distribué d'Après Son Organisation: Pour Servir de Base à l'Histoire Naturelle des Animaux et d'Introduction à l'Anatomie Comparée. Les Crustacés, les Arachnides et les Insectes* (The Animal Kingdom Organized According to Its Structure: To Serve as a Foundation for the Natural History of Animals and an Introduction to Comparative Anatomy. Crustaceans, Arachnids, and Insects), 1817

Description

* **Class:** Malacostraca
* **Order:** Decapoda
* **Family:** Cancridae
* **Genus:** *Cancer*
* **Habitat:** Atlantic coast of Europe, from Norway to southern Morocco and to the Aegean Sea
* **Lifespan:** 20 years
* **Weight:** 3¼ lb. (1.5 kg)
* **Length:** 12 in. (30 cm)
* **Diet:** detritivore, necrophagous, also feeds on crustaceans, invertebrates, mollusks, sea worms, gastropods
* **Characteristics:** robust, nocturnal

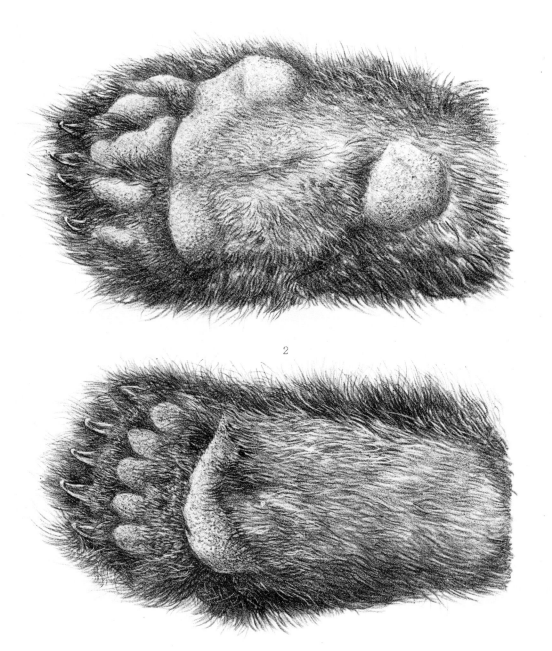

Ursus arctos horribilis

Anonymous
Grizzly Bear Paws, Palms Up
1868–74

Plate in Henri and Alphonse Milne-Edwards,
*Recherches pour Servir à l'Histoire Naturelle des
Mammifères: Comprenant des Considérations
sur la Classification de Ces Animaux*
(Research on the Natural History of Mammals:
Including Considerations on the Classification
of These Animals), volume 2, atlas
Muséum National d'Histoire Naturelle,
Central Library, Paris

Unlike other subspecies of the brown bear, the grizzly can stand on its hind legs, reaching a maximum height of 10 ft. (3.1 m). This defensive, confrontational posture also enables the bear to see and better smell an object or animal. It has a highly developed sense of smell. Its teeth are long and sharp, but its primary weapons are its 6-inch-long (15 cm) crescent-shaped claws, which make it easy to recognize a grizzly pawprint: it can be identified by an oval pad with five toes at the top of the back paws. Grizzlies use their claws to dig up the earth in search of roots, marmots, and ground squirrels. They can also be used to strip a bison or mark a bear's territory on tree trunks. The grizzly's highly sought-after coat contains brown and white fur, which gives the animal a gray appearance depending on the season. This coat can grow up to 2¼ in. (6 cm) thick. In winter, the grizzly enters a state of semi-hibernation, from which it can awaken in case of attack, unlike other bears. During this period, the animal shelters in a cave, crevasse, or tree trunk. This is also the time when females give birth. When winter is over, grizzlies shed their fur by scratching themselves or rubbing up against trees. Despite its bulk, the grizzly is a good runner—reaching speeds of up to 41 mph (66 km/h)—a good climber, and an excellent swimmer. The grizzly does not defend a territory, but rather a space about 165 ft. (50 m) in diameter. When another bear or human enters this space, the grizzly chooses one of two options: to flee or to fight.

Source: Capitaine Mayne-Reid, *Bataille avec des Ours* (Battle with the Bears), 1884

Description

- Class: Mammalia
- Order: Carnivora
- Family: Ursidae
- Genus: *Ursus*
- Habitat: Canada, Alaska
- Lifespan: 20 to 25 years
- Weight: 275½ to 772 lb. (125 to 350 kg)
- Height: 3 ft. 6 in. to 4 ft. 3 in. (1.05 to 1.30 m)
- Diet: plants, berries, roots, shoots, ferns, fish, clams, insects, small mammals
- Characteristics: solitary

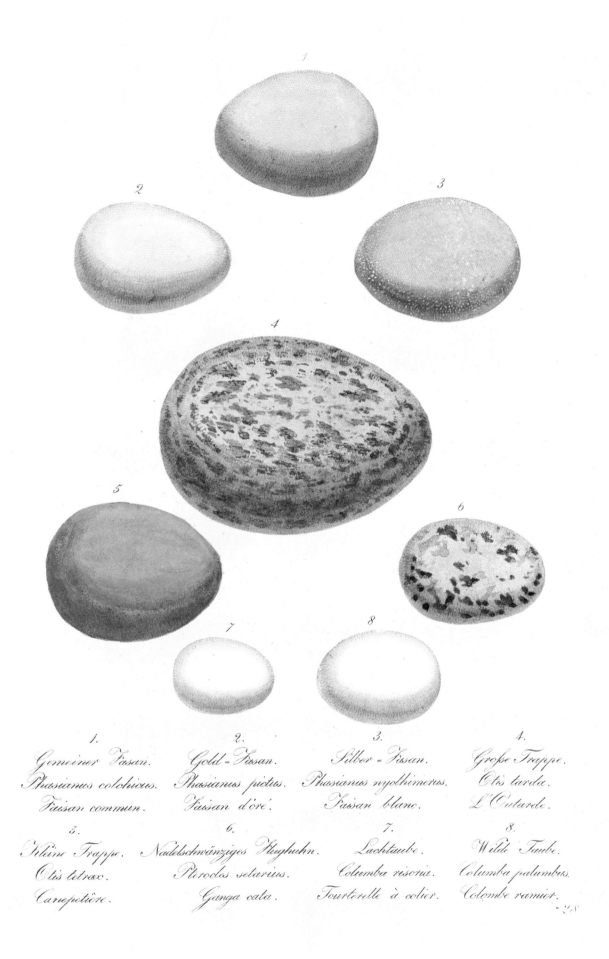

1.	2.	3.	4.
Gemeiner Fasan.	Gold-Fasan.	Silber-Fasan.	Große Trappe.
Phasianus colchicus.	Phasianus pictus.	Phasianus nycthimerus.	Otis tarda.
Faisan commun.	Faisan d'oré.	Faisan blanc.	L'Outarde.

5.	6.	7.	8.
Kleine Trappe.	Nadelschwänziges Flughuhn.	Lachtaube.	Wilde Taube.
Otis tetrax.	Pterocles setarius.	Columba risoria.	Columba palumbus.
Canepetiere.	Ganga cata.	Tourterelle à colier.	Colombe ramier.

Ova

Anonymous
Eggs
1819

Plate in Heinrich Rudolf Schinz, *Beschreibung und Abbildung der Künstlichen Nester und Eier der Vögel, Welche in der Schweiz, in Deutschland und den Angränzenden Ländern Brüten* (Description and Illustration of the Artificial Nests and Eggs of Birds Found in Switzerland, Germany, and Bordering Countries)
Muséum National d'Histoire Naturelle, Central Library, Paris

The egg protects and nourishes the embryo. It is made up of an external and internal membrane, a yolk, albumen, an embryo, and chalazae (tissues that anchor the egg yolk to a larger structure), all of which is surrounded by a protective, highly resistant shell made of crystals of mineral salts. Minuscule pores in the shell allow the embryo to breathe through it. There are three main egg shapes: oval, spherical, and long and elliptical. The size of an egg generally corresponds to the size of the bird, although there are a few exceptions. The eggs on this plate, all similarly shaped, are distinguished by their color and size. The eggs in the top rows (numbered 1–3) are pheasant eggs. The female lays a dozen eggs on average, which incubate for between 23 and 25 days. The egg in the center of the plate (4) is from a great bustard. The female lays two or three eggs, which are pale gray or green with brown and gray spots. The female broods on them for between 25 and 28 days, until they hatch. The other spotted egg (6) is from the pin-tailed sandgrouse (*Ganga cata* or *Pterocles alchata*). The female lays three eggs that may be anywhere from whitish-gray to pale brown to pink in color, with dark brown, chestnut, reddish, or light gray markings. Incubation lasts 19 or 20 days. The deep green egg (5) is from the little bustard. The bird's two to five eggs are laid in a simple divot and incubated for 21 days. The smallest egg depicted (7) is a turtledove egg. The turtledove can lay two eggs at a time, up to six times a year. The female and male take turns brooding on the eggs for 14 to 18 days. The last egg (8) is from a common wood pigeon. This white egg is incubated for 17 days by both parents.

Source: Dr. Joseph-Émile Cornay, *Mémoire sur les Causes de la Coloration des Oeufs des Oiseaux et des Parties Organiques Végétales et Animales* (Essay on the Causes of Coloration in Bird Eggs and Organic Plant and Animal Parts), 1860

176. Lootsmannetie. Le Pilotte des Balaines. Celuy-cy est la Femelle.

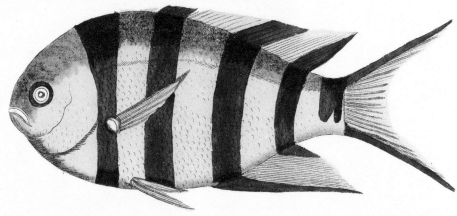

177. Lootsman des Hayen. Pilotte des Balaines. Le Masle.

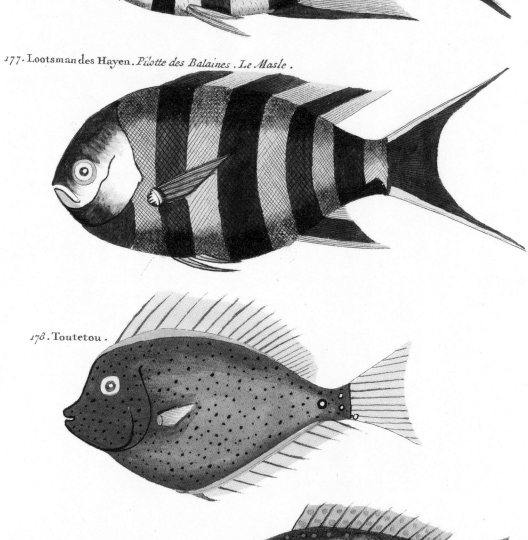

178. Toutetou.

179. Gallenav Pavan.

kk.

Abudefduf sexfasciatus

Anonymous
Exotic Fish
1754

Plate in Louis Renard, *Poissons, Ecrevisses et Crabes de Diverses Couleurs et Figures Extraordinaires que l'On Trouve Autour des Iles Moluques et sur les Côtes des Terres Australes* (Fishes, Crayfishes, and Crabs, of Diverse Colors and Extraordinary Form, Found Around the Islands of the Moluccas and on the Coasts of the Southern Lands), folio 33 Muséum National d'Histoire Naturelle, Central Library, Paris

This zoological plate presents drawings of four fish from the Moluccas islands in Indonesia and the Indian Ocean. It is taken from a collection published by Louis Renard, an agent of the British Crown. The top two fish (female and male) are *Abudefduf sexfasciatus*, commonly known as the scissortail sergeant. Its silvery gray body, marked with five vertical blue-black stripes, can grow up to 6¼ in. (16 cm) in length. Each jawbone has 48 to 52 incisor-shaped teeth. The dorsal, anal, and caudal fins are the same color as the body. The male becomes darker during reproduction. It can be found in shallow reefs, reef flats, and lagoons, where it swims between the surface and up to 49 ft. (15 m) deep. The third fish is *Pempheris molucca* 'Cuvier'. This fish is coppery red with gold or steel highlights. The underside and head are more golden in color than the rest of the body. Each scale has a reddish-brown point and a smooth, steel or light gold-colored space without a point. A row of scales running along the body is made up of 22 to 52 scales. The fins are reddish yellow. This fish is found near the Moluccas islands, where Malaysian fishermen call it *ikan-batou*. It was the subject of particular study by Professor Reinwardt for the Royal Museum of the Netherlands. The last fish is a Gallenay Pavan.

Source: Georges Cuvier, *Histoire Naturelle des Poissons* (A Natural History of Fish), volume 7, 1831

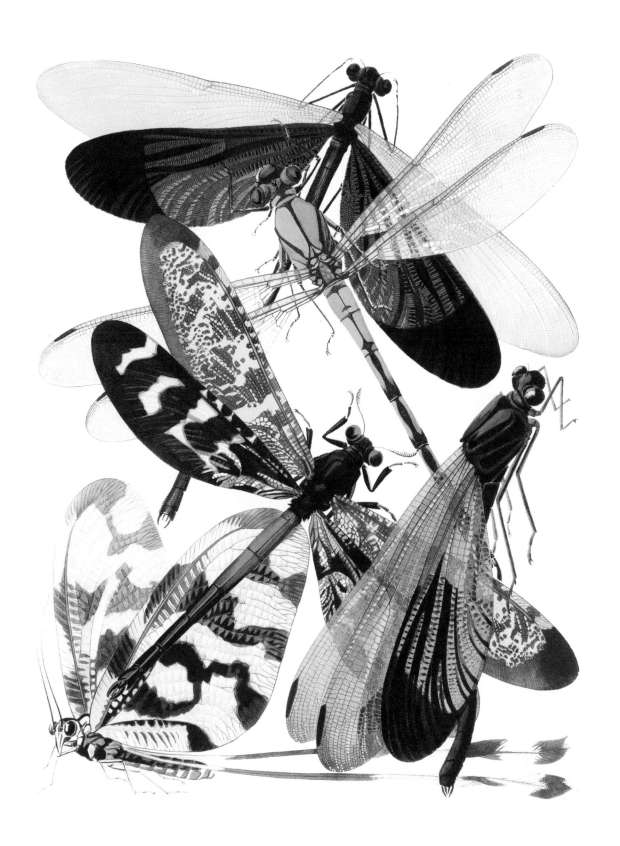

Insecta

Émile-Allain Séguy
Insects
1929

Plate in Émile-Allain Séguy,
*Insectes: Vingt Planches en Phototypie Coloriées
au Patron Donnant Quatre-Vingt Insectes
et Seize Compositions Décoratives*
(Insects: Twenty Colored Phototype
Plates Depicting Eighty Insects
and Sixteen Decorative Compositions)
Victoria and Albert Museum, London

From around 1900 to 1930, Émile-Allain Séguy became one of the main creators of decorative designs, and his output reflected both art nouveau and art deco styles. On graduating from the École des Arts Décoratifs in Paris, his collections of repeated graphic elements on the same theme earned him much attention. In the 1910s, his work shifted to focus on designing ornamental motifs. Two portfolios in particular are remarkable: *Butterflies* (1928) and *Insects* (1929). Each plate is composed of several overlapping and enlarged stencil drawings of different species. Although Séguy cast aside the codes of the classic anthropological plate, he faithfully and scientifically reproduced the forms and colors of insects and butterflies, which rendered his work extremely precise and accurate. In his foreword, he affirms, "no interpretation or fancy has been applied to the colors either." To carry out his work, the artist spent many years studying scientific publications, and private and museum collections. For even more precision, he kept an index of the names and origins of insects. The plate presented here is number 10 from the collection, which was published by Duchartre and Van Buggenhoudt in Paris in 1929. Five kinds of insects are depicted. The damselfly at the top of the page is an Australian *Calopteryx*, which resembles the damselfly on the lower right, an Asian *Calopteryx*. Both have a bottom set of wings, blue in color, on half or three-quarters of their surface. The damselfly to the left is a *Palpares imperator*. The insect located on the lower left is a *Nemoptera sinuata* (spoonwing), adapted to the absorption of pollen and nectar. Finally, the center of the plate is taken up by *Diphlebia nymphoides*, an Australian damselfly. Here, Séguy depicts an adult male, recognizable by its black and blue striped tail.

Source: Henri Miot, *Les Insectes Auxiliaires et les Insectes Utiles*
(Helpful Insects and Useful Insects), 1870

Text by
Cindy Lermite

Design
Roman Rolo

French Edition

Editorial Director
Julie Rouart

Administration Manager
Delphine Montagne

Editor
Mélanie Puchault

English Edition

Editorial Director
Kate Mascaro

Editor
Helen Adedotun

Translated from the French by
Kate Robinson

Copyediting
Penelope Isaac

Typesetting
Claude-Olivier Four

Proofreading
Nicole Foster

Production
Corinne Trovarelli

Color Separation
Les Artisans du Regard, Paris

Printed in Belgium by Graphius

Front cover: © Shutterstock / visualstock
Originally published in French as *Bestiaire*
© Flammarion, S.A., Paris, 2019

English-language edition
© Flammarion, S.A., Paris, 2020

87, quai Panhard et Levassor
75647 Paris Cedex 13

editions.flammarion.com

20 21 22 3 2 1

Distributed by Rizzoli/Penguin Random House:
978-2-08-020442-4

Distributed by Thames & Hudson and Flammarion:
978-2-08-020449-3

Legal Deposit: 03/2020

Creating Your Home Gallery

These prints can be framed effortlessly; they fit standard 9 × 12 in. or 24 × 30 cm frames (6 × 8 in. or 15 × 20 cm frames for the half-page prints). They also look attractive pinned to the wall with decorative thumb tacks.

For an attractive display, the works should ideally be placed 1¼ to 2 in. (3 to 5 cm) apart. Ensure the frames are equally spaced.

Alternate between portrait (vertical) and landscape (horizontal) formats for variety and harmony.

Align certain frames so as to create visual lines and add structure to the overall display.

Try distancing similar designs from each other to create additional visual interest.

The secret to creating a successful display is to establish interactions between key elements formed by colors or contours. A horizontal line will be the perfect counterpoint to a vertical motif, for example.

Changing the display regularly will instantly update your decor.